Kodak New Pocket Guide to Digital Photography

© Charlie Brethauer

Kodak New Pocket Guide to Digital Photography

Quick advice on getting great pictures!

Published by Lark Books
A Division of Sterling Publishing Co., Inc.
New York

Book Design and Layout: Tom Metcalf
Cover Design: Thom Gaines
Associate Art Director: Lance Wille

Library of Congress Cataloging-in-Publication Data
Kodak new pocket guide to digital photography : quick advice on getting
great pictures! — 1st ed.
 p. cm.
 Includes index.
 ISBN 1-57990-946-9 (pbk.)
 1. Photography—Digital techniques—Handbooks, manuals, etc. II. Title.
 TR267.K625 2006
 775—dc22
 2006015420

10 9 8 7 6 5 4 3 2 1
First Edition
Published by Lark Books, A Division of
Sterling Publishing Co., Inc.
387 Park Avenue South, New York, N.Y. 10016

Distributed in Canada by Sterling Publishing,
c/o Canadian Manda Group, 165 Dufferin Street
Toronto, Ontario, Canada M6K 3H6

Distributed in the United Kingdom by GMC Distribution Services,
Castle Place, 166 High Street, Lewes, East Sussex, England BN7 1XU

Distributed in Australia by Capricorn Link (Australia) Pty Ltd.,
P.O. Box 704, Windsor, NSW 2756 Australia

If you have questions or comments about this book, please contact:
Lark Books
67 Broadway
Asheville, NC 28801
(828) 253-0467

Manufactured in China

For information about custom editions, special sales, premium and corporate purchases, please contact
Sterling Special Sales Department at 800-805-5489 or specialsales@sterlingpub.com.

Kodak
LICENSED PRODUCT

Photo opposite:
© Charlie Brethauer

Contents

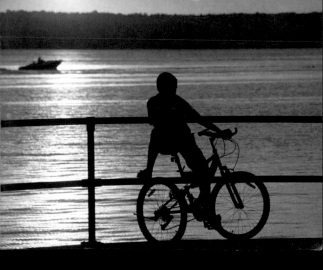

DIGITAL CAMERAS

Today's digital cameras look and act mostly like traditional cameras. Yet, there are a number of very important differences, including some that truly enhance our picture-taking experience. This introduction offers an overview of what you can expect from a digital camera.

Benefits of the Digital Camera

Digital cameras offer a number of terrific advantages. Chief among them is that you can see and evaluate the picture immediately. You can also use a picture almost the moment you take it—especially if you have a camera with wireless capability and are near a "hot" spot. And quality is top notch. Even a simple 4-megapixel camera can easily make an exceptional 8 x 10-inch print. And let's not forget the cost advantage of not paying for film every time you take a picture.

© Kevin Kopp

No Cost Pictures

Digital cameras are quite affordable. Their memory cards have become quite inexpensive when you consider how many photos they can store. Plus, the cards can be used over

© Charlie Brethauer

and over again. This is a wonderful thing because you no longer have to worry about wasting film! If you think a photo might be interesting, take it. If you wonder what a certain setting on the camera will do, try it. You can't lose!

Instant Feedback

The camera's LCD monitor lets you check every aspect of an image, from composition to exposure, from white balance to the use of flash. You can quickly see if you got the photo you expected or if you need to correct problems while you are still with the subject. Just think of what an advantage this is when taking pictures of your vacation or special family events!

Quick Change Light Sensitivity

With a digital cam-
era, you can instant-
ly change its light
sensitivity to respond
to different condi-
tions by adjusting
the ISO setting. With
a push of a button
or a new selection in
a menu, you have
performed the film-

© Charlie Brethauer

camera equivalent of changing film. And you can do this for a series of photos or one at a time; you have the choice.

Colors Stay True

One problem with traditional photography is that the color of light affects how color looks in a photograph. Just think about all those old green photos shot under fluorescent lights—the scene never looked green to our eyes. With a

digital camera's white balance control, this all changes. Now it is possible to maintain normal colors under almost all lighting conditions.

More Freedom to Shoot

When you put all the advantages of digital photography together, the combination spells freedom. You are free to shoot whatever you want, whenever you want, without as many restrictions in terms of cost, color, light levels, and more. You can erase any photo that doesn't turn out well. You can experiment with new techniques and subjects without worrying that you are wasting costly film.

More Connection to the Subject

Because a digital camera gives you instant feedback, you can take a picture and experience the subject, the photograph, and your feelings about the image all at once, all while you are still with that subject. This changes the picture-taking experience and gives you an incredible connection to your subject.

© Charlie Brethauer

More Fun Making Pictures

Digital cameras today are exciting, extremely friendly to use, and offer some totally new ways of dealing with images. This combination of more possibilities for success with the ability to experiment at no cost (including getting rid of the bad stuff instantly) usually leads to photography that is more fun!

Different Types of Cameras

Digital cameras are often grouped into types such as point-and-shoot or SLR. Within these categories there are various levels of sophistication and different price points. Here is a quick look at the important buying considerations so you'll understand how digital cameras work and what features you really need, whether you are buying your first or upgrading to something new.

© Eastman Kodak Company

Mini Digital Cameras

Most manufacturers offer very small, well-designed, stylish, mini digital cameras. These can be divided into several categories based on features and operation. They also come in various sizes, from the super-mini that fits a shirt pocket to the larger, yet still compact, zoom cameras. Be careful of the really small cameras because the LCD may be so small that it can be hard to see your images.

Basic Point-and-Shoot Cameras

These totally automatic cameras are designed for casual photography. They offer few operational choices beyond simply turning the camera on and off. Some don't even have zoom lenses. These cameras generally have fewer megapixels and lower quality lenses. Camera speed and processing capabilities are limited and lag time (click-to-capture) is longer.

© Mimi Netzel

Standard Point-and-Shoot Cameras

These cameras are a clear step up in functionality and image quality. They offer more functions to increase your picture-taking versatility, often including picture-taking modes that give settings customized for particular shooting situations, such as scenic, action photography, and low-light photography. With more megapixels and a good quality zoom lens with close-up capability, you can get quite good pictures. Camera speed and processing capabilities are limited and lag time is usually noticeable.

Sophisticated Point-and-Shoot Cameras

These cameras take you to the next level in capability and design. Cameras in this group feature higher megapixels, white balance options, ISO setting flexibility, multiple exposure modes, multiple focus modes, expanded zoom range, and special features such as weatherproofing. Camera speed and processing capabilities are improved, and while lag time is still significant, it is reduced.

© Eastman Kodak Company

Advanced Compact Cameras

Cameras in this group offer some professional level features and quality. In fact, some pros carry them as second cameras. Their high megapixels and features rival those found on some digital SLRs (D-SLR) but their size is smaller than a D-SLR. These cameras combine easy-to-use auto functions with a wide range of choices for white balance,

© Eastman Kodak Company

ISO settings, exposure modes, plus specialized modes for focus and color balance. These models include both built-in and external flash capabilities. With wide zoom ranges, image stabilization, and excellent quality, their lenses are often made with pro-level materials. Camera speed is the best, short of D-SLRs, and processing capabilities are superb. While there is still slight lag time, it is manageable. These cameras are designed for moderate to heavy amateur shooting requirements.

Digital SLR Cameras

Digital single-lens-reflex (D-SLR) cameras offer through-the-lens (TTL) viewing, interchangeable lenses, and other advanced features. Manufacturers often offer several D-SLRs to meet multiple requirements.

• Pro cameras: These are generally heavy, quite expensive, and their controls are not necessarily designed for ease-of-use.

• Advanced amateur: These D-SLRs typically feature all-metal bodies, moderate moisture and dust sealing (not weatherproof, which means it can have a built-in flash), moderate start up time and processing speed, and high-speed autofocus.

• Family or Mass Market: Generally smaller and easier to use, these D-SLRs are also relatively less expensive. They usually have slower start-up time and processing speed, as well as less sophisticated autofocus. This is tricky, though, because a camera introduced today in this category may easily beat many features of more expensive cameras introduced a year ago.

All D-SLR cameras accept accessory flash units, interchangeable lenses, filters, and other accessories. Due to the reflex viewing system, most of these cameras do not allow you to preview an image on the LCD monitor before taking the picture (i.e., there is no live preview). However, the LCD monitor can be used for reviewing recorded pictures and for in-camera image editing.

© Kevin Kopp

Check These Features Before Buying

Here is a quick look at important buying factors so you'll understand how digital cameras work and what features you really need, whether you are purchasing your first or upgrading to something new.

Megapixels

More megapixels give you greater flexibility, meaning you can make larger prints, or you can crop your pictures and still have good image quality. Usually the higher megapixel cameras offer the most advanced features, so even if you don't need the megapixels, you may want the features.

Electronic Viewfinder (EVF)

Similar to viewfinders found in camcorders, these use a miniature LCD monitor that is magnified as it is seen through an eyepiece. This can take a little getting used to. When buying a camera with this feature, make sure the image looks smooth, has good brightness and contrast, and color looks realistic.

LCD Monitor

© Eastman Kodak Company

This important feature is what makes the digital experience work so well. However, some small cameras have too small an LCD to be truly useful. Turn it on and be sure it has good size, decent brightness and contrast, shows good color, and is easy to view.

Handling

This is an extremely important part of a camera selection process. You really have to hold the camera, try the controls, and see how it feels. A chart of features will never tell you this. If you don't like the way a camera feels or handles, you probably won't enjoy using it and your results may not be as good.

Ease of Use

Controls from one digital camera to another are neither consistently placed, nor are operations controlled by a uniform set of dials or buttons. Since we all handle cameras in different ways, how controls are accessed for logical operation is important. Are they easy to find and use? Check to be sure the menus are clear and easy to read, as well.

Features You Need

Think seriously about the type of pictures you like to take. You may find that you need special capabilities such as close-focusing, minimal shutter lag, noise reduction for long exposures, built-in flash controls, second-curtain flash sync, slow flash sync, bulb exposure, and so on.

© Charlie Brethauer

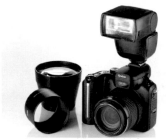

© Eastman Kodak Company

The Camera System

Various manufacturers of digital cameras offer different choices of add-on lenses, flash units, and other accessories. Different brands of D-SLRs offer a variety of approaches to similar accessories. Before deciding upon a particular brand, make sure the accessories you need are available.

The Sensor

This is the light-sensitive part of the camera that reads the scene as focused by the lens. All sensors are composed of an array of tiny light "photo sites," made of photodiodes that produce electricity when stimulated by light. These sites represent the smallest picture particle, or element—the pixel. Usually sensor resolution is measured in effective pixels, which is the actual area being used by the camera for photography.

Some smaller compact digital cameras have megapixel specs that are similar to or higher than some D-SLRs. However, these smaller cameras feature physically smaller sensors than those found on D-SLRs. Small sensors have less exposure latitude and usually create poorer quality pictures. It is harder to get a clean, noiseless image from a small sensor, especially with low light and high ISO settings. However, in good conditions with low ISO settings (usually 100 or less), these cameras can offer images that rival those taken with much larger cameras.

© Charlie Brethauer

Camera Speed

Several factors play a part in how quickly a camera takes pictures.

• Boot-Up Time: This is the length of time it takes after a camera is turned on until it is actually ready to shoot an image.

• Lag Time: Lag time is the delay between pressing the shutter release and when the camera actually goes off (from click-to-capture). This period varies tremendously among digital cameras. A long lag time can cause you to miss potential photos because the subject might change in the time between when you release the shutter and when the image is actually recorded.

• Buffer and Processing: Processing determines how fast a camera can capture the data from the sensor and move it to the internal buffer, where it is stored until the camera automatically downloads it onto the memory card. This will be expressed in frames per second (fps). Once the camera's internal buffer is full, the camera must stop taking pictures until space is opened up by transferring data to the memory card. On compact digital cameras, the buffer is relatively small and you might only get 6-10 photos before the camera stops. Many new advanced zooms and D-SLRs feature larger, faster buffers.

Moving Pictures

Most non-D-SLR cameras offer a neat little feature—video capture. The quality of video capture has rapidly improved. Although some cameras still offer a resolution of half the television standard, 320 x 240 dpi, many now offer the television standard of 640 x 480 dpi. Videos eat up storage space, so you'll need a large memory card.

Frame rate is another important issue. The standard frame rate for video is 30 fps, but digital camera video may be recorded at a lower frame rate, which may look choppy when played back. Video from a still digital camera used to be limited to short time periods, but motion pictures in today's cameras are usually restricted only by the size of the memory card.

Having a camera with video capture offers the chance to get some high-quality video quickly and easily. It is ideal for snapshot videos, to grab quick and easy video of the kids, for example. Plus, downloading the captured video is easy—just use a card reader and drag and drop the files from memory card to hard drive.

2

UNDERSTANDING CAMERA BASICS

While the automatic functions of today's digital cameras work very well, with a little help from the photographer, they work even better. Understanding your camera's features and functions and how they operate will give you more picture-taking options and will produce better pictures, especially when confronted by challenging situations or subjects.

The Marvelous LCD Monitor

If just one thing could be picked as the best feature of a digital camera, the instant feedback of the LCD monitor would definitely get the nod. Even a beginning photographer with a basic digital camera can quickly see how the photo looks and then make adjustments.

The "live" LCD found on most digital cameras is even better because it lets you see, before you take the picture, what white balance looks like, how exposure is looking, and so forth, which can be very helpful. (D-SLRs cannot give you a live LCD, because of the mirror used to reflect light from lens to viewfinder.)

© Charlie Brethauer

In addition, using the LCD to review images after they are taken has made professional results more accessible to all photographers. There is no longer the "hope I got it" attitude. Instead, one just checks and re-shoots. The LCD offers many advantages to digital photographers. Among them:

© Charlie Brethauer

Image Review and In-Camera Editing

The LCD permits you to review and access your photos at any time. The ability to edit as you go is convenient and easy. You simply call up an image on the LCD, evaluate it (including enlarging it to see sharpness detail) and keep or delete it. You may want to safeguard some images so they cannot be easily erased—most cameras offer a "lock" function for that purpose.

Exposure and Composition Check

You will quickly know if your settings are right or wrong, if you should continue with the same choices, or try something new.

Improves Your Photography

Looking critically at your photos as you are shooting makes your subsequent pictures better. Plus, deleting the "bad" shots not only clears them from the memory card, but also from your mind. You can focus on what is working for you.

Clear the Clutter

Eliminate the junk and you won't have to deal with it later. For most photographers, having a group of images that is really pleasing means you will return to them again and again for printing or other uses. Even if you edit just a little as you go, you make your job much easier later.

In the film and video industries there is always a lot of talk about "coverage" (or capturing the subject from different angles, varied distances, and so forth). By looking over your photos as you go, you can evaluate your coverage of the subject.

Optimize Memory Cards

Even though cards are getting better and less costly, cleaning up the trash is a good habit that will optimize their use and encourage you to shoot more pictures.

© Mimi Netzel

Resolution

This is sometimes confusing because resolution refers to three different things: area resolution, linear resolution, and printer resolution.

Area Resolution

This is the total number of pixels in a digital photo file and is stated as two numbers, for example 3000 x 2000 pixels. Multiply the pixels in the example and you get a total of 6,000,000 pixels, which equals 6 megapixels in the camera.

Linear Resolution

This is the number of pixels per linear dimension, such as ppi (pixels per inch) or dpi (dots per inch). Technically, ppi and dpi are not the same, but they have become inter-changeable in general use. Linear resolution is meaningless without a total image size or dimension for reference such as 8 x 10 inches (20.3 x 25.4 cm) at 200 dpi.

Printer Resolution

This is the resolution of a printer, such as 1440 dpi, and is a separate function that is set independently of camera resolution.

Making Sense of Resolution

With a digital camera, our main concern is area resolution. This tells us how much data we have to work with and affects image size more than anything else. One misunder-standing is that megapixels equal sharpness. This is not the case—you can have a very sharp image from a 3-megapixel camera and an unsharp photo from a 6-megapixel camera. You can also make 4 x 6-inch (10.1 x 15.2 cm) prints from 3, 6, or even 12-megapixel cameras and they will look essentially identical in sharpness.

Increased resolution gives you more detail—revealed in larger prints. On a basic level, you need approximately 2 megapixels for up to a 5 x 7-inch (12.7 x 17.8 cm) print, 3 megapixels for an 8 x 10, 8 megapixels for 16 x 20 (40.6 x 50.8 cm). These numbers are somewhat conserva-tive, but will give quality prints from a photo inkjet printer.

© Charlie Brethauer

Setting the Camera

On your digital camera, you probably have several resolution options available. Most of the time you should use the maximum resolution offered by the camera. That's what you paid for, after all. You can always reduce the size of an image, but increasing it back to a larger size (that it could have been in the first place) will never give you the highest quality.

If you need only to display photos on the Internet, you may find it easier and more efficient to shoot at a lower resolution. This will give you smaller files that transfer faster, take up less space, and can be worked on quickly.

File Formats

File formats can also be confusing, especially since you'll hear some people say it is best to shoot in one format, while others tell you it is best to shoot in another. For general picture taking, use the JPEG format. It gives good quality and takes up less space.

TIFF (Tagged Image File Format)

This is an ideal format for working with photographs in the computer. But it is not ideal for the camera because TIFFs are large files that slow down cameras and hog memory card space. This is why most cameras no longer offer this format. Pictures saved as TIFFs are identified by .tif file extension.

JPEG (Joint Photographic Experts Group)

JPEG is an international standard for compression technology that offers a small file with superb detail. Higher JPEG compression settings create smaller files that fit easily on the memory card, although files can start to lose important data if overly compressed. This is because JPEG is a "lossy" format, meaning data is lost as the file is compressed. At low compression (high quality) settings, most of the lost data can easily be rebuilt when the file is uncompressed. Bottom line: JPEG can work great, but it should be used at the best quality settings most of the time. JPEG pictures have a .jpeg file extension.

Caution: Don't do your image editing with JPEG files! This "lossy" format loses image data each time you re-save. Open the JPEG files and save them in another format, such as TIFF, before you start editing.

RAW

This file type creates data with minimal processing—just as it comes from the sensor. RAW offers more color data with its 16-bit file compared to the 8 bits of JPEG. This increased data can allow for stronger adjustments and changes to the image file without problems occurring. RAW files are proprietary for each camera manufacturer. You need special software to read these files and to process them. RAW files have proprietary file extensions.

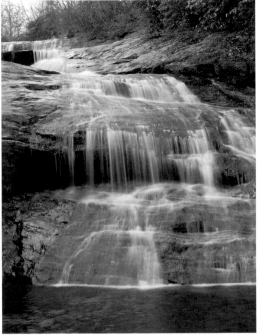
© Kevin Kopp

The Epic Battle

JPEG vs. RAW—the battle of the digital age. You will hear
photographers say you must use one or the other. It has
even reached the point where some photographers say
that they don't want to use JPEG because it is an "ama-
teur" format with poor color and tonality. Not true. Look
at the photos throughout this book. Almost every one,
with just a few exceptions, was shot using JPEG. But many
pros swear by RAW. They like the extra flexibility they get
in processing the image after the shot.

What is important is the photography you do and your
way of working, not what some other digital photographer
wants you to do.

ISO Settings

Digital cameras offer the ability to change ISO settings as you go. Here are three key things to consider when choosing ISO speed:

• Image Quality: Low ISO settings yield clean images with fine detail, good color and tonality, plus little or no noise (noise often looks like confetti in a picture). For optimum image quality, use the lowest ISO speed possible because noise increases as ISO speed increases. However, there are times that a higher ISO speed will make the difference in getting or not getting a shot. Higher settings on D-SLRs are less affected by noise.

• Shutter Speed: Higher ISO settings allow you to use a faster shutter speed. This can be extremely helpful when handholding your camera, especially with the telephoto end of some zoom lenses on small digital cameras. Faster shutter speeds will also freeze action better.

• Flash Range: With any given flash unit, whether built-in or accessory, higher ISO settings will give you more range.

Noise

A clean, noise-free photograph can be a beautiful thing. Noise in an image is seen most easily in large, smooth-toned areas such as sky. It appears as tiny specks of random color and light, which can obscure fine detail and alter colors. In addition to increased ISO settings, there are several common sources of noise.

Sensor Noise

You have no control over the sensor itself (more expensive digital cameras often control noise better in their processing circuits). However, if you shoot in bright light and restrict the use of higher ISO numbers, you will minimize the noise in the image from the sensor.

Exposure

It is important to expose images well so that dark areas have enough data for you to work with. Underexposed areas are very susceptible to noise.

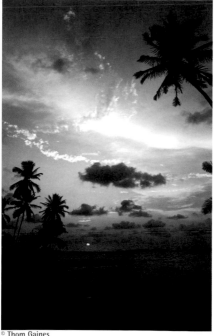

© Thom Gaines

JPEG Artifacts

Utilizing a JPEG compression in the camera that is too high, or repeatedly opening and saving a JPEG image in the computer, can create blocky details that look like chunky grain—noticeable in areas that have slight gradients of tone, such as sky. Set your camera to its best quality (lowest) compression.

Sharpening

Sharpening in the camera and the computer can overemphasize noise. All too often, when the entire photo is sharpened, slight noise suddenly gets very ugly. When possible, sharpen only in the computer, and even then, only the well-focused parts of the photo.

Image Processing

Image-processing software can increase the appearance of noise. Overuse of Hue/Saturation, for example, will dramatically bring out undesirable grain, so use the software's preview and watch for unwanted noise. Avoid over-processing image color.

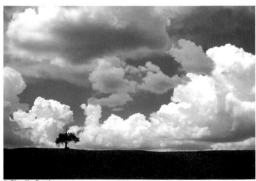

© Charlie Brethauer

The White Balance Function

A new control for most photographers, white balance is important to understand because it can be both a corrective and creative tool. Once you see the benefits of white balance, you will be glad that you have mastered its use.

The Color of Light

Our eye-brain connection makes most types of light look neutral so that colors stay consistent. A white shirt looks white to us whether it is in the shade, in the sun, or indoors under fluorescent lights. Yet those three lighting types have very different inherent color, which cause color shifts in photography. To keep colors looking normal in different types of lighting, digital cameras feature a white balance control.

How the Camera Adjusts

To achieve white balance, the camera looks at the white and neutral colors of a scene, either automatically or with your help, and makes them appear neutral. This control renders color accurately, making it look correct in a scene regardless of the light source, whether indoor fluorescent or mid-day sun.

But sometimes it can go too far, making the warm light of a sunset, for example, technically "correct" yet lacking the warmth we expect in a photograph of a sunset.

It is true that you can make color adjustments in the computer, and if your camera lets you shoot RAW images, you can totally change white balance after the fact. However, in most cases it is best to adjust your white balance while you are shooting.

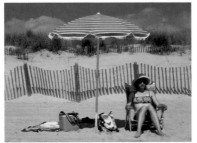

© Charlie Brethauer

Automatic White Balance

Automatic white balance can be useful for shooting quickly in changing light conditions, however don't set it as your standard. The auto setting often gives inconsistent results simply because it is an auto function that is making the best of a world that varies in terms of color and light.

White Balance Presets

Most digital cameras offer preprogrammed white balance settings for common types of lighting, such as Sunlight, Shade, Cloudy, Sunset, Tungsten (household lamp), and Fluorescent. The preset usually gives better results than the automatic white balance. For example, using the sunlight white balance setting on a sunny day gives excellent results whatever the color of the subject. But if you move into the shade to a take picture of your daughter, change it to the shade setting for pleasing skin tones. Remember to change it each time the type of lighting changes.

© Charlie Brethauer

White Balance as a Creative Tool

You can also change the response of the camera so that color is rendered warmer or cooler for creative purposes. In this way

you can create a sunset that looks more like you expect it to look (use the Cloudy or Flash settings). Also, you can intentionally make a cold winter day appear even colder (try Tungsten). Experiment with different white balance choices and check your LCD to see what they do to the picture.

Custom or Manual White Balance

Another level of white balance control is the ability to read a card and cutomize the white balance setting. This feature is available on more advanced digital cameras, but sometimes missing from simpler cameras. Customizing your settings can be very helpful to precisely match a given lighting condition.

To do this, point your camera at something white or gray (it does not have to be in focus) and follow the procedure for color balancing. The camera analyzes the specific white or gray tone and adjusts the color so that it is truly neutral. This can give quite remarkable results in tough situations, such as fluorescent lighting.

RAW and White Balance

Finally, shooting in RAW increases color balance options. RAW files give you the ability to go back and change your original white balance choice. This helps compensate for the inconsistencies of automatic white balance, but it requires more of your time after you take the picture. This will mean you can get much better consistency with multiple images. However, this should never be an excuse for not setting white balance as best you can.

3

GET THE MOST FROM YOUR CAMERA

> It pays to understand different operations of your digital camera. You don't have to become a "professional" to enhance your camera's (and your) ability to shoot good photographs, but it helps to comprehend and appreciate the fundamentals.

Autofocus (AF)

Autofocus performance has a number of important attributes: speed, single or continuous focus, number and location of sensors, and AF light sensitivity. Advanced cameras usually do these better, but this is not simply a matter of camera price, since newer AF technologies often enable lower-priced cameras to beat older, more expensive cameras.

© Charlie Brethauer

© Robert Ganz

Speed and Type of AF

Camera speed is affected by the type of selected AF: single or continuous. Not all cameras offer this choice. In single-exposure AF, the camera will not take a picture unless the autofocus has focused on something, which is fine for most shooting but can be a problem with moving subjects. Using a camera that only has single-exposure AF, you'll often get frustrated because it won't let you take pictures when it has trouble focusing. Continuous focus lets the camera shoot as it is focusing. Some advanced cameras even use something called predictive AF that allows the camera to keep up with the action. This is most common in D-SLRs.

It is possible to get very good shots even when the action is quick, but you must anticipate the action and "pre-focus" by locking the AF on something where you expect the action to go (this is especially important with non-D-SLR cameras). This takes a little practice, but the neat thing about digital is being able to review action shots on the LCD. You can check your shots and quickly learn how to best capture the action in front of you.

AF Sensor Location

Location of the focusing sensors in the image area also affects how the autofocus will work. More advanced cameras will often have a group of sensors across the viewing area that makes it difficult for the subject to elude detection. Some cameras even let you set the sensor for specific areas to match a composition you want. Lower-priced cameras may have only one sensor for the whole scene—that can make it harder for the camera to find and lock focus, so you, the photographer, may have to do more work by always moving the camera slightly to be sure focus is found by the sensor.

AF Considerations

One last thing to consider is how bright the conditions are. Low light or low contrast subjects can make it difficult for the camera to autofocus. Even the least expensive of the more advanced cameras typically have AF assist beams that operate in dark conditions. Be aware that these can be inappropriate for some locations (where a bright light in the dark would be rude or even dangerous).

Exposure

Exposure control has become so good that your pictures are almost always of the correct brightness. However, sometimes a "good" automatic exposure from the camera isn't actually the best exposure for the subject. To get an exposure that truly expresses your intent or adds mood, you may want to darken or lighten the picture by adjusting exposure controls. And you need to know how to use those controls for the situations that can trick the exposure system into creating a picture that's too dark or too light.

® Martha Morgan

Understanding Meters

A camera's meter is calibrated to expose all scenes as middle gray, or average. It can't really tell if a scene is filled with objects that are light, midtone, or dark. Ideally, under the same

lighting conditions, the meter should expose all the objects equally. Unfortunately, the meter sometimes makes light objects too dark and dark objects too light. To compensate, camera manufacturers have developed sophisticated metering systems that include multiple metering points and computer or microprocessor analysis.

Exposure Compensation

For most photographic situations, the camera's smart metering system offers excellent exposure. Problems occur when the scene is mostly very dark or very light, when there is extreme contrast in the scenes, and when a bright light (like the sun) shines into the lens, especially when it is near an AF focusing point. Once you understand how your meter reacts to light, you can use the exposure compensation feature, if offered, to make a quick adjustment. Exposure compensation allows you to increase or decrease the camera's autoexposure in small steps (usually in 1/3 or 1/2-stop increments—some cameras let you choose the interval, some only offer one choice).

Exposure Lock

Most digital cameras will lock exposure on whatever they see if you depress the shutter release slightly (usually about halfway). For example, suppose you were shooting a sunrise, but a large part of the scene had a darkly silhouetted rock. In addition, the camera is focused on the rock. That large dark area connected to the focus point would likely throw the meter off, resulting in the sunrise starting to lose color (from too much exposure).

With standard digital cameras (not D-SLRs), you can see this happening in the LCD. You can then move the camera so it sees more sky and less rock, and lock the exposure. Then reframe the picture. Some cameras have specific exposure lock buttons, too. With a D-SLR, you have to first take the shot and then check the review.

Exposure Modes

Most advanced digital cameras on the market offer multiple autoexposure modes that use the complete metering system to give you a good exposure. These modes feature approaches to exposure that meet varied needs of photographers, but you don't have to use them all.

Full Auto and Picture Control Modes

Sometimes called a "point-and-shoot" mode, Full Auto mode rarely allows exposure compensation or any other adjustments. This is a great mode for casual family snapshots or vacation photography.

Many cameras also include special automatic modes called Picture Control or Subject modes, which are designed to work with specific subjects such as Portraits, Landscapes, etc. These usually affect more than just exposure—such as flash, focus, and aperture or shutter speed.

• Portrait: This mode favors wide lens openings to render the face in soft-focus with diffused backgrounds.

© Thom Gaines

• Landscape: Designed for scenic photography, this mode selects small apertures to increase depth of field so as much of your shot as possible is sharp.

• Action or Sports: High shutter speeds are chosen to stop action.

• Flash-Off: This mode is helpful for long exposures or anytime you don't want the flash to go off.

• Night Portrait or Slow-Sync Flash: These modes balance the foreground flash and existing-light background exposure so that backgrounds do not appear dark in the photo. It is also useful for more than night photography (try it on people on a gloomy, cloudy day, for example).

• Close-Up: This mode sets a moderate aperture to balance a faster shutter speed (to minimize the effects of camera movement during the exposure) for close focus work.

© Thom Gaines

User-Controlled Exposure Modes

Many digital cameras offer additional, more sophisticated exposure modes.

• Program Mode (P): The camera sets both the aperture and shutter speed for you. If your camera allows Program Shift, you will be able to quickly change the camera-selected shutter speed and aperture combination while maintaining an equivalent exposure.

• Shutter-Priority Mode (S or Tv): You select the shutter speed and the camera sets the aperture for you. This allows you to control how action is rendered in the photograph.

• Aperture-Priority Mode (A or Av): You set the aperture (lens opening) and the camera chooses the shutter speed. This gives you control over depth of field (see pages 42-43). All else being equal, smaller apertures (larger f/numbers) maximize depth of field. However, you must be aware of the shutter speed the camera is selecting to prevent the possibility of unsharp pictures due to camera movement.

• Automatic Exposure Bracketing (AEB): Offered on some advanced cameras, this feature can generally be used with Program, Shutter-Priority, and Aperture-Priority modes. The camera's exposure bracketing system automatically varies exposures in a series of three photos, which deviate by a set range from the metered value. This gives you exposure choices in the finished images.

• Manual Exposure (M): If offered on your camera, manual exposure is useful when you have tricky lighting, when shooting panoramic photos where side-by-side photos must match, when you are trying to match flash with existing light, or for creative effects.

Some cameras offer several metering options for the user-controlled exposure modes, like center-weighted and partial metering. A center-weighted system biases the average toward meter sensors in the center of the photo and decreases the weighting of sensors toward the outside of the frame. Partial metering focuses on a small spot in the image area (usually the center).

© Charlie Brethauer

Depth of Field

Depth of field is the range of apparent sharpness from front to back in a photograph. It is a factor that may allow you to have both a flower in the foreground of a photograph and the mountains in the background in sharp focus. With all other variables the same, three things influence depth of field: f/stop, distance to the subject, and the focal length in use.

Controlling Depth of Field

Let's look at these different factors that control depth of field:

• f/stop: Small lens openings (the big numbers such as f/11) increase depth of field, and large apertures (such as f/2.8) decrease depth of field.

• Distance: The farther you are from the point of focus, the greater the depth of field. The closer you get, the shallower depth of field becomes. (This makes close-up photography a real challenge at times.)

• Focal length: Wide-angle focal lengths give greater apparent depth of field, while telephoto focal lengths reduce depth of field. When you need to have a scene appear sharp from close to far, use the wider settings of your zoom or add a wide-angle accessory lens. If you want to limit sharpness through a selective focus technique (where one point is sharp and everything else is out of focus), try using a telephoto setting or a telephoto accessory lens.

Beyond "Good" Exposure

The best exposure for a digital camera is the one that gives you the best image/data for its intended purpose. If you want to make a great print, you need to have the appropriate exposure data for highlights and shadows that can be processed in the computer. If you want to make a print directly from camera to printer, you need to know what works best with the printer (e.g., does it make prints lighter or darker than the version on the LCD?).

Also important is how exposure affects the subject. A dramatic but dark mountain might look weak and washed out when shot with a basic autoexposure mode. Similarly a bright beach might look dim and less than sunny with a standard meter reading. You need to interpret your exposures, and here again, the LCD comes through with a technological advantage.

Using the LCD and Histogram

One of the truly great advantages of digital cameras is their ability to let you review exposure on the LCD. It can quickly tell you if a scene is so contrasty that you cannot capture all the possible detail. It will show you if the subject has been captured appropriately: Are the dark trees dark and white buildings bright? It will give you ideas so you can change exposure to match the needs of the scene. It helps you decide if the photograph is going the way you want it to. If you enlarge the image, you can usually see if needed detail exists in highlights or shadows.

However, there will be situations when the little LCD monitor isn't as ideal as you'd like for evaluating exposure. That's when the histogram is used. While expected on advanced cameras, it is surprising how often a histogram shows up on lower-priced cameras.

The histogram is a graph that tells you about the exposure levels in your shot. For photographers who are new to digital, the histogram's techy graph look can initially be confusing or even intimidating. My suggestion is to try it! At its basic level, the histogram is simply a graph of the number of pixels with specific brightness values from dark (on the left) to bright (on the right).

How to Interpret What You See

A good exposure of an average scene will show a histogram with the graph above the bottom line from left to right, without an imbalance of brightness values on one side or the other. The range of tones for important brightness areas of a photograph should finish before the end of the graph at one side or the other. Whenever the histogram stops like a cliff instead of a slope at the sides, it means the exposure is "clipping" detail. If detail is important for dark (left) or bright (right) parts of the photo, you need to adjust exposure to bring the slope of the histogram back into the graph.

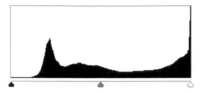

This shows a distribution of tones that indicates overexposure.

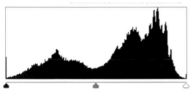

This histogram demonstrates a normal exposure.

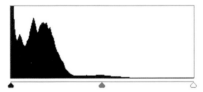

This photo is underexposed. It will be too dark.

How the detail in the histogram is arranged can also help you evaluate your exposure. If you're photographing a bright scene, the histogram should show most of the values to the right. Since bright subjects can be easily under-exposed, those values may at first sit to the left half of the histogram. This is the wrong place for them. For dark scenes, the story is similar—these values belong on the left. Use exposure compensation in automatic modes to shift the histogram to the right or left.

LENSES AND FLASH

Using Lenses

A range of focal lengths, whether incorporated in your camera's zoom or from interchangeable lenses, gives you greater capability in getting the shots you want. Wide-angles let you photograph in limited spaces or allow you to capture open landscapes. Telephoto focal lengths are just the opposite of wide-angles with their ability to zero in on a scene, magnifying it and compressing distance. They also allow the photographer to step back from the subject and still get a reasonably sized image.

The industry uses an important convention to talk about lenses with digital cameras: 35mm equivalents. A lens' focal length is meaningless without a reference to the image area, or frame size, within the camera. Different digital cameras will have different imaging areas, which makes any comparison of focal lengths between two cameras a real challenge unless there is some direct baseline. This is the 35mm equivalent, giving a number that shows what a lens offers compared to the same angle of view as a lens on a 35mm camera.

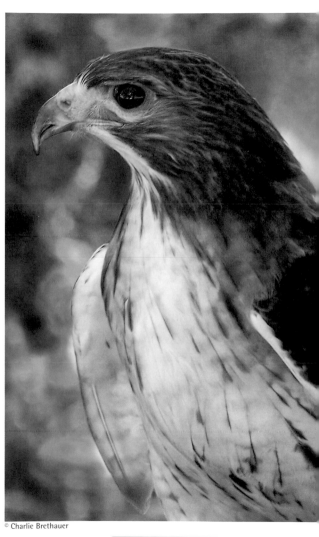

© Charlie Brethauer

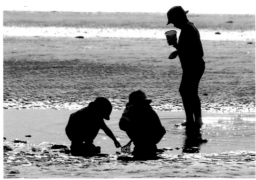

© Robert Ganz

Lens Speed

Lens speed refers to how much light a lens lets into the camera at its widest aperture—the maximum f/stop. This is the number that is always given when referring to a lens and its focal length. For example, a digital camera with a 35-105mm (35mm equivalent) f/3.5 would be a zoom lens with a maximum aperture of f/3.5. The wider the aperture, the faster the lens. A faster lens lets you use faster shutter speeds (or lets the camera select these speeds). This helps when you need to shoot action, obviously, but it also helps when the light gets low.

Accessory Lenses

Digital cameras often have a focal-length range that may not be as wide as you want and may fall short of long telephoto focal lengths needed to photograph wildlife or sports. With D-SLRs, you can buy additional lenses, and with most advanced digital cameras you can purchase accessory lenses that increase the width of a wide-angle and magnify the length of the telephoto end. These accessory lenses can be very good and relatively inexpensive.

Besides focal length changes, accessory lenses can help with close-ups, both on small digital cameras and interchangeable lenses for D-SLRs. They transform your camera zoom into a macro zoom. I am not talking about the inexpensive close-up lenses or filters, but about highly corrected achromatic, multi-element close-up lenses. While most digital zoom cameras have close-up settings built-in, this typically is very limited at the telephoto settings. These close-up lenses let you use all focal lengths at macro distances for great close-ups.

Lens Savvy

There are many lens applications that make significant differences in your photography. Of course, with a digital camera, you can check the results of any changes in the use of your focal lengths in the LCD and determine how best to apply the following variables.

Angle of View: Most people select a focal length based on the angle of view of the lens. If you are traveling and expect to be taking pictures in confined spaces, nothing but a wide angle will do. If you are photographing a soccer game where the action takes place from near to far, you'll need a zoom lens that provides a whole range of angles of view. With wildlife, a telephoto is critical.

© Charlie Brethauer

A variant of angle of view is magnification. Sometimes you really do want to think about magnifying a shot—getting a closer shot of a tiger at the zoo or finding an architectural detail in the ceiling of a cathedral. Since you cannot physically move closer to such subjects, the only way to do this is by magnifying the image.

Perspective: Perspective is a major tool for image control, is affected by focal length choice, and is therefore heavily used by pros. It is one skill that sets off his or her images from everyone else's. Perspective is how we see size and depth relationships of objects within a picture.

Simply zooming your lens in and out does not change perspective. Perspective is a function of distance plus focal length. The trick is to move as you zoom, so the subject stays the same size, but the background changes. This requires you to move closer with the wide-angle shot because the lens will see more in the scene. Or you will have to back up with the telephoto since otherwise the lens would see a smaller section of the composition, missing the right amount of the foreground subject. The wide-angle shot makes the distant parts of the scene appear smaller and more distant, while the telephoto makes them appear bigger and closer.

Flash Made Easy

Handy flash units are built into nearly all compact digital cameras, plus you can add an accessory flash unit to any digital camera that has a hot shoe. Both manufacturers' and some camera brand-specific units marketed by independent companies work with all the bells-and-whistles you'd expect in a modern flash unit. (If you are not sure if a unit will work with your camera, check with your photographic dealer.)

You may be surprised at how much you can do with a built-in flash. You have a secret weapon compared to the days of film: take a picture and check it! Your digital camera gives you the actual image on the LCD.

Basic Flash Exposure

Some digital cameras will send off a burst of light called a preflash an instant before the flash exposure actually occurs. The preflash allows the camera to determine the exposure. This happens so fast that most people don't notice. For the actual exposure, the flash fires and cuts itself off when the proper amount of light has been cast.

© Kevin Kopp

Red-Eye Reduction Flash Settings

Red-eye in flash photos of people is distinctly unattractive. It generally occurs in dark situations when flash is used. It is caused when light from the flash reflects off the subject's retina. With small digital cameras, the flash is so close to the axis of the lens that red-eye is almost guaranteed.

The red-eye reduction function will either cause a preflash to occur, making the subject's iris narrow, or it will emit a light to do the same thing. While this is helpful, it can also create photographic problems. Often the subject will react poorly to this preflash, so the photos may show less red-eye, but the person's reaction creates an unflattering picture.

You can also reduce the occurence of red-eye by using an accessory flash. This larger unit is farther away from the axis of the lens. In addition, many software programs now include easy-to-use red-eye reduction tools that allow you to take the good shot and not worry about red-eye while you take it. There are even some cameras that include red-eye removal in the camera itself.

Easy Flash Options

Most photographers use a flash aimed directly at the subject. This direct type of flash is useful when you need to see things in dark conditions or when your subject is some distance from you, as with sports or wildlife photography.

Another use of direct flash is fill flash. This allows the flash to brighten shadows in very contrasty light. It is an ideal use for a built-in flash. Watch people taking pictures of each other on a bright, sunny day. Notice that the bright sun creates strong shadows on faces and under hat brims. Yet, although most of these people have cameras with a built-in flash, the photographer rarely turns it on. Almost every digital camera can have the flash set so it flashes at all times. Again, the great thing about this technique with a digital camera is that you can always see the results and there is no cost to experiment. Try turning on your flash in bright or even gray day conditions and see what you can get.

Unfortunately a lot of indoor flash photos look like those deer-in-the-headlights paparazzi images. This type of lighting isn't flattering to the subject and can produce harsh, rather unattractive photographs. There is one thing you can do with your built-in flash to avoid this: Allow

some existing or ambient light to be exposed in the background. (Check your camera's manual to see the best way to do this. If your camera has a slow-sync or night flash setting, try that.) This immediately makes the flash look less harsh.

© Simon Stafford

If you can use an accessory flash unit, there is a very easy way to get better photos: bounce flash. It can be used with any flash that tilts, or with off-camera flash. Here, you point the flash at a white surface (ceiling, wall, reflector, etc.). This spreads the light out and softens its edges. It can be a very attractive and natural looking light for interiors and is especially effective when photographing people.

5

ACCESSORIES FOR DIGITAL PHOTOGRAPHY

There are additional items you will need in order to take full advantage of digital photography. It is true, you don't need to buy and process film, but you will need memory cards and batteries. You may also want to invest in other accessories, such as a card reader, a tripod, or camera bag.

Memory Cards

Memory cards are sometimes called "digital film" since they record images and can be removed from a camera like traditional film. While there are differences, thinking of a memory card this way is helpful. It is worth knowing a little about memory cards in order to get the most from them.

Memory cards come in a variety of sizes and shapes and the different types are not interchangeable. The type of memory card has absolutely no effect on image quality; it is simply a storage device.

© Robert Ganz

CompactFlash (CF) Cards

These are solid, reliable memory cards about the size of a matchbook and come in two versions—Type I and Type II. Most cameras that use CF cards accept both, though today, the most common is Type I. There is little that can damage CF cards. If you drop one in the mud or sand, clean it and plug it back in. Water will not hurt them, but high heat will.

SD and xD Cards

Many of the smaller digital cameras use these cards, which are not much bigger than your thumbnail, therefore smaller than CF cards (xD cards are the smallest). They do allow manufacturers to make cameras more compact. SD and xD cards are newer technology and often offer faster speeds, even better than the best of CF cards today.

Memory Sticks

These are a unique type of memory card that Sony uses for its cameras. They look like a stick of gum and offer no advantages over other cards.

SmartMedia

This type of memory card was very common a few years ago, but has some limitations for camera manufacturers, so it is gradually disappearing from the market. It is very thin, about the size of a CompactFlash card.

Memory Card Capacity

Memory cards can have different capacities to store digital information, ranging from 16 megabytes (MB) to four gigabytes (GB) or more. So what size do you need? It depends on how you like to shoot. Below is a chart that shows how many photos fit on particular sized cards. You can see that

RAW files mean a lot fewer images saved per memory card megabyte. You can obviously get by with much less memory when shooting high-quality JPEG.

If you want to try one of the really large, multi-gigabyte cards, make sure your camera can handle it. Do you buy a single big one and never change cards? Or would a number of smaller ones better meet your needs? There is no simple answer to this. It is more a personal preference as to how you would like to work.

Camera Megapixels	File Format	Memory Card Capacity			
		128 MB	256 MB	512 MB	1GB
4	JPEG	64	128	256	500
4	RAW	24	50	102	200
8	JPEG	36	73	146	286
8	RAW	14	28	57	111

Note: These capacities are approximate since JPEG is a variable compression format and actual sizes of files may change based on the image and amount of compression.

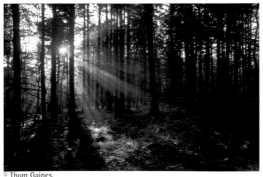

© Thom Gaines.

Downloading Pictures
from Memory Cards

Once you have your photos stored on a memory card, you will need to save them elsewhere. You will want to get photos off the card so they can be used in other applications, and also to clear your card for reuse.

Downloading with the Camera

With KODAK EASYSHARE cameras, it's easy to get your pictures onto the computer. You simply place your EASYSHARE camera on a KODAK EASYSHARE printer or camera dock, press a button, and your pictures are ready to transfer to the computer. That's easy. And the dock recharges your camera's battery. For KODAK camera owners, it's the easiest way to move pictures onto the computer. Some EASYSHARE and other cameras use a wireless connection that doesn't require a direct hookup to the computer.

You can also connect most digital cameras to the computer via a cable. The memory card must be in the camera. You hook one end of the cord to a port on the computer and the other end to the camera. When you turn on the camera, the computer will usually recognize it and open a window so you can transfer pictures to the computer.

An imaging program that comes with the camera or computer enables you to handle your pictures on the computer. KODAK EASYSHARE software comes with KODAK cameras (or can be downloaded for free by anyone at www.kodak.com). It focuses on simplicity. With it you can easily organize, edit, print, or share your pictures and video clips. Other software may offer more complex features for accomplishing similar tasks.

© Martha Morgan

Using Card Readers

The majority of newer computers have built-in card readers into which you simply insert the memory card. If your computer lacks a card reader, you can buy an inexpensive stand-alone card reader to plug into the computer (USB or FireWire). Most of these devices read multiple card types— this can be a real benefit if you have more than one camera and they use different cards. Otherwise, you will probably just want the simple, less expensive unit that only reads the type that your camera uses.

A card reader is easy to use and very affordable. You simply take your memory card out of the camera and put it into the slot to transfer picture files. The computer will recognize the card as a new drive (on some older operating systems you may need to install a driver for the card reader, which will be on software that comes with the unit).

The card reader now allows you to work with the image files. If you are not familiar with how computers deal with files, transferring images may take some learning. But if you have even basic computer skills, you will find that this reader now allows you to work with the image files just as you would any other files—like selecting all the photos on the card and copying them to a new folder on your hard drive.

The process is pretty simple

1. Set up a folder on your hard drive to hold your transferred photos (you can name it something related to your photos, such as Soccer Tournament July date).

2. Plug in your card. When it appears on your desktop (maybe with a downloading wizard), open the folder and find the photos.

3. Select all the photos (Command/Ctrl A).

4. Drag and drop them to the folder you set up for your transferred photos (this will copy them there).

5. Use a browser program such as ACDSee or iView Media to review, edit, and sort your photos.

Finally, if you take a lot of photos, I would strongly suggest checking out a FireWire reader. While more expensive (and requiring a FireWire port on the computer), it is a great convenience because it downloads files so very, very fast. This can be quite important if you have big cards filled with images.

Laptops with FireWire and USB connections work in the same way. Some even have slots specifically for memory cards (usually the common CF card) for direct transfer. Most Windows laptops also have PC card slots (the old PCMCIA slots) and you can get memory card adapters that fit into these slots. Transfer of images from these slots can also be very, very fast.

Taking Your Card to a Lab

Many photo enthusiasts are finding another way of transfer quite attractive—using a lab. Take your memory card to the minilab where you, or the lab, download the images and make prints. The major benefit of using a lab is that

you can take advantage of a digital camera without using or owning a computer. By going to a lab, you can get those prints done quickly and easily. Even if you enjoy working with pictures in the computer, labs can be handy when you need quick snapshots for friends and family.

Clearing the Card

You've downloaded your images. Now what's the best way to erase images off of a memory card—camera or computer?

• Erasing the Card: When a memory card is erased, no image files are actually destroyed or removed from the memory. Erasing removes only location/identification data that tells the computer where the file is located. Once this location/identification data is removed, new photos can overwrite the old image files. Once new photos are saved, the original photo is "lost" since its information has been overwritten.

• Reformatting the Card: When formatting, the camera or computer completely rebuilds the directory structure of the card (which tells any device reading the card how to find the data). This results in the erasure of the photos by removing locating links to the actual data. It can be accomplished by using either the computer or the camera.

Hint: All of the technical gurus I have talked to recommend using the camera for erasing and reformatting of the card. Formatting your card in the camera lowers the risk of corrupting or accidentally changing the file system of the card.

Maximizing Image Sharpness

Slight camera movement during the exposure can lead to blurred photos. With a good tripod, this doesn't happen. When you are handholding a camera, it is free to move or "shake," especially with small, lightweight digital cameras. A fast shutter speed will "freeze" the movement to maintain sharpness, but at a certain point the shutter speed will not be fast enough and blur will occur.

Using a tripod and remote to fire your camera will insure sharp pictures by eliminating the possibility of camera shake due to handholding. © Kevin Kopp.

Because compact digital cameras are so small and easy to handhold, it is easy to get lulled into the idea that they don't ever require a tripod. But tripods are useful for all types of cameras.

You can get very handy, compact tripods for small digital cameras that will fit in a carrying bag. These are small, but they can be set up anywhere—on a table, a rock, against a wall, and so forth, and they'll help a lot. Bean pods are

quite handy little devices that fit in most camera bags. They provide a soft foundation that cushions and stabilizes the camera on a hard surface, such as against a railing or fence post.

There is no question that tripods will help you get the most out of your camera and lens, but you need to invest in a good one. A cheap, flimsy tripod can be worse than none at all. And don't look for a tripod with a long center column—they are extremely unsteady.

Batteries

Even though manufacturers have developed power-conserving technologies, batteries in a digital camera still run down in a very short time compared to film cameras (where you might replace batteries once a year).

Everyone uses cameras differently, so pay attention to how you use certain power-hungry parts of your camera, which include the LCD monitor, built-in flash, and autofocus. Conserve when possible. For example, a number of cameras allow you to select different periods of time after which the camera and/or the LDC will power down and go to "sleep."

The proper battery does make a difference in battery life, too. A number of digital cameras use only a proprietary battery that comes from the manufacturer. Typically, cameras with proprietary batteries are using rechargeable lithium-ion batteries, which have a high power output for its size and the power is very stable.

Their disadvantage is inconvenience. If your proprietary battery dies you will not be able to walk into a local supermarket and buy a new one. You really need a second, fully-charged battery to rotate with your original as a reserve.

Many cameras do use AA-sized batteries, however alkalines lose power quickly. The two best AA battery types for photographers are rechargeable nickel-metal-hydride (NiMH) batteries and non-rechargeable lithium batteries. Rechargeable NiMH batteries hold and release power well, but they lose power when sitting unused. If you don't use your camera for a month, you might discover your batteries are drained even though you had just charged them before you put the camera away. And NiMH batteries need to be charged and discharged a few times before they reach their full capacity after purchase. They need to be "conditioned" through a few charging cycles.

Charging Batteries

High-speed chargers are great when you are in rush, but they shorten the overall life of a battery. Use standard chargers when you can to get the longest life from your batteries.

© Robert Ganz

Carry extra batteries in your camera bag. Few things are more disappointing than failing to shoot important pictures because your batteries died. © Charlie Brethauer.

Back-Up Batteries

Since batteries are essential to digital camera operation, it is important to have multiple sets. Carry at least two, or better yet, three batteries (or sets of batteries) per camera. They don't take up that much space and you don't ever want to be caught with a dead battery just as you are ready to shoot.

IMAGE PROCESSING

Whether you want your photo to give a pleasing likeness or say something special, you will want to prepare the image file by using an image-processing software program that adjusts and enhances your picture. Choose a program to meet your needs. Intermediate users can create excellent photos for display using software such as Microsoft Digital Image, Ulead PhotoImpact, or Photoshop Elements. Advanced and professional users might opt for Photoshop or Jasc Paint Shop Pro.

Play around with your program to learn how the different tools perform. This is a craft and you will get better with practice. There are several basic adjustment controls that it pays to learn and use on your image file before you try to make prints.

© Thom Gaines

Levels

Common to most programs, Levels lets you adjust brightness, contrast, and color. It appears as a graph (called a

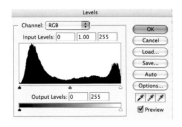

histogram) and shows the range and quantity of tones in your picture: deepest black (0) on the far left, brightest white (255) on the far right.

Move the three triangles under the graph to lighten and darken the picture. To darken (and increase contrast), drag the black slider to the right until it is under the rising start of the histogram. To lighten, move the white slider to the left until it is under the end of the histogram.

Continue to nudge these sliders toward the center to further increase contrast. But don't move them too far or you will lose detail in both the light and dark areas. By moving the middle (gray) slider, you can lighten and darken midtones.

You can also reduce or increase individual colors (red, green, or blue and their combinations) using these triangles by using Channel drop-down menu.

The final Levels controls are the three eyedroppers: Use them to neutralize colors. Select the black eyedropper icon on the far left and click it on a black area in the picture to neutralize dark tones and set the darkest value. Select the white eyedropper icon on the far right and click it on a known white object to set neutral colors and to set the brightest white value in your picture.

If you check the preview box, you can see these changes when you move the sliders or use the eyedroppers.

Curves

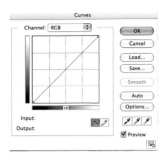

Curves is another graphic tool for adjusting brightness, contrast, and color. However, using it effectively takes practice. It is great for adjusting contrast and midtones after you have set the black and white points. Click the cursor on the middle of the diagonal line and pull it up to lighten the midtones or push it down to darken. Usually, you don't need to move it much to see the effect.

Next, if you wish to favor the dark grays or the light tones, you can click again in the lower or upper part (respectively) of the graph. You now drag the curve up or down to affect a part of the curve, which results in a more isolated effect on the tones of the photo. If the curve moves too much in an area that you don't want, click on the graph in that area to anchor it to that point.

Selections

When only a portion of your picture needs to be adjusted, you can select just that section to work on. Several selection tools can be used individually or together. They include shaped selection tools (rectangles and circles), freehand Lassos (which follow your cursor) and automatic tools (the Magnetic Lasso and the Magic Wand).

Selection Tips

• Enlarge your image: You can better see edges of your subject.

• Add and subtract from the selection in order to refine it: Hold down the Shift key as you make selections to add to the area, and the Alt or Option key to subtract.

• Use more than one Selection tool: Depending on the shape you want to select, try one of the several selection options.

When you have made your selection, feather it. Feathering is a blending or smoothing of the selection edge. Selected edges are generally much sharper than those that would naturally occur in a photograph. Feathering takes that edge off.

Hue/Saturation

With the Hue/Saturation tool, you can subtly (or wildly) adjust colors and their intensities. You can also select a specific part of a photo, for example, a red flower, and adjust its hue, or even change the color altogether.

Often, digital cameras produce files that print with less color intensity than you might remember from film. Try bumping the saturation up 10-15 points and see if that helps.

In a number of programs, you can actually isolate the Hue/Saturation adjustments to a particular color by choosing only that color to adjust. If the blue sky seems dull, pick Blue in the Hue/Saturation tool before you make your adjustment. Only areas with blue pixels will then be affected.

Layers: New Possibilities of Control

The key to understanding Layers is to realize that they separate your adjustments into distinct and isolated pieces of an image. Think of it as putting a stack of identical photos on your desk. Each photo is a layer in that pile. When you look at the stack from above, you only see the top photo. Cut a piece out of that top photo and you can see some of the photo under it. If you keep cutting pieces out of photos as you go down through the stack, you'll be able to see parts of the lower images. If you do something to the photo under a solid layer with no cutouts, you won't see the effect because the top photo hides it.

To get started using Layers, try Adjustment Layers. This can be very helpful with printing, because it allows you to adjust what a photo looks like without changing the underlying file. Plus, it allows you to go back later and readjust if you don't like the effect on the print. There actually is nothing in an adjustment layer except instructions. These instructions can be set to affect tonal controls as well as color. And since Adjustment Layers always work from the top layer down, they affect whatever is underneath them.

You may also find Duplicate Layers quite helpful for printing. These are layers with identical images in them, like a stack of photos. You can experiment and try different effects on the various layers and compare them fairly easily, because all the layers are right there on your computer desktop. Since duplicate layers are separate, anything you do to one has no effect on the others, and you can compare them quite easily.

© Robert Ganz

Sharpening the Image

For a print to look its best, its image file usually has to be sharpened. Sharpening brings out the fine details in the file.

One of the best sharpening tools is the Unsharp Mask, which in spite of its name, gives a great deal of control over sharpness. (The name is a relic from the commercial printing industry meaning to mask unsharpness.) This tool has three different controls that can be adjusted separately for optimal sharpness.

Once you open Unsharp Mask, you'll discover a window with sliders that control the Amount, Radius, and Threshold.

Amount

Amount represents the intensity of the sharpening effect, which increases differences along edges of contrast in the photo. Usually you'll want to set a value between 100 and 200% in Photoshop and Photoshop Elements (this range does change from program to program—experiment first with the lower range of numbers). Typically, I find that digital camera photos look good in the 120-140% area.

Radius

Radius determines how much of an edge change is used in order to make the sharpening effect. Generally, this is most effective in the 1-2 pixel range, using lower numbers (they can be set as decimals) for smaller file sizes (say 10MB or less) and higher numbers for larger files. Watch out for over sharpening, which adds harshness to the image and rings or halos of white around dark edges.

Threshold

Threshold tells the program at what contrast to look for differences along edges. Low settings give the most sharpening effect— if you can use 0, go for it. However, a low Threshold setting will cause the program to sharpen and overemphasize grain and noise. Typically, a Threshold between 3-10 works well and minimizes grain problems, but you will have to increase the Amount setting.

GETTING THE RESULTS YOU WANT

How many chances do you get? Many when you're photographing Cinderella's Castle during the daytime at Disneyworld. One when a kayaker plunges over the brink of a waterfall or your son puffs his cheeks and starts to blow out the candles.

Regardless of whether you get one chance or several to make it right, the final picture can be spot on. But you will want to understand how to make the proper settings on your camera, how to implement a few standard shooting techniques, and why it is important to review the image on the camera's LCD monitor while on location to make sure it is high quality. In short, establishing a workflow from start to finish assures you have the best possible picture file for printing later.

© Martin Schamus

© Thom Gaines.

Setting up the Camera

Let's assume you want pictures of the highest quality possible. Use the following camera settings before taking a picture and consider them your default settings.

Generally Use Best JPEG File Format

RAW and JPEG (highest or finest quality) are offered on most of today's digital cameras RAW gives you the widest range of digital information to work with. It lets you make basic adjustments to unprocessed data after a picture is taken, but it takes extra time in front of the computer to convert and process the image.

The highest quality JPEG setting gives excellent results while letting the camera store more pictures and take them faster. You may want to use the best JPEG setting for most pictures and RAW when lighting is tricky.

Resolution

Use your camera's highest resolution setting. Lower settings will reduce your ability to make big prints or crop an image.

© Martin Schamus

White Balance

For best results, manually choose the white balance setting that corresponds to the lighting in the scene (custom white balance is even better but it's time consuming—see your camera manual). When in doubt or in a hurry, use Auto White Balance.

Image Adjustment Settings

Turn off, or set to minimum, settings for saturation and sharpness. You can better adjust these in image-processing programs.

Low ISO

A lower ISO setting gives better image quality with all cameras, avoiding excessive noise. Shoot at ISO 200 or below unless low lighting requires extra sensitivity.

Key Shooting Techniques

Once your camera is set up properly, use these basic shooting techniques to continue the quality workflow you've started.

Clean Lens

Check that the lens is clean. A smudge on the lens can degrade the images.

Shade the Lens in Bright Sun

Use a lens shade if you have one. If you don't and the sun is shining on the lens, hold your hand in front of the lens to block direct sunlight from hitting it. Direct sunlight can cause flare that lowers contrast and sharpness or appears as halos in the picture.

Frame Accurately

Compose the picture so you don't have to crop it later. Cropping reduces resolution and limits the size you can print a picture. But if you're uncertain, don't hesitate to take extra pictures showing more of a scene.

Don't Use Digital Zoom

Digital zoom is a form of in-camera cropping. It lowers resolution. In general, avoid using it. When it's the only way to get close enough to a subject, okay, use it.

Minimize Camera Movement

Even slight camera movement during picture taking can soften a picture. To counteract camera movement, do one of the following:

- Practice good handholding technique.
- Use a shutter speed of 1/100 second.
- Use a tripod (the sturdier the better).

It is important to hold the camera properly. With your right hand, hold the grip of the camera while placing your index finger on the shutter release. Cradle the lens and body with your left hand, keeping both elbows pressed gently into your torso. Place your feet slightly apart to create a sturdy foundation.

Use a Mid-Range Aperture

Most camera lenses give best results at a medium aperture (f/stop) setting. That would most likely be f/8 for D-SLRs and a smaller f/number for non D-SLR cameras.

Checking Image Quality

The next step is verifying that your quality techniques have worked. You can check some of the critical areas right after you take the picture.

Verify Exposure is Correct

Reviewing your pictures in the LCD can give you an idea of how successful the exposure was. But the best way to check exposure is with your camera's histogram (assuming it has one) as displayed on the LCD. The histogram graphically shows pixel values of your picture. For normal scenes, the graph should extend from the far left (black tones) to the far right (white tones) with peaks and valleys in between. (See pages 44-45).

Verify Sharpness

Many LCDs let you magnify a picture to examine sharpness. They're good enough to reveal badly blurred pictures but not subtly blurred pictures.

Review Composition

Look at your pictures on the LCD for composition. In people pictures, check for an awkward pose, closed eyes, or funny expressions.

© Charlie Brethauer

Good People Pictures

Speaking of people pictures, the most popular photographic subject of all time is just that: people. That's to be expected. The camera excels in documenting our life, and our lives revolve around our family and friends.

Parents love to record events, both big and small, that mark the lives of family members. And from those pictures come albums that document the history of the family.

Whether you're a family photographer or simply a people photographer, you'll find the people you photograph tend to fall into two categories—kids and adults—that require different approaches. And photographing kids and adults falls into two broad photographic styles: formal portraits and fun candids.

Kids

Photographing young children, particularly reluctant children, requires you to be creative, effective, and patient.

You need two sets of skills. The first is photographic techniques suited to the subject. The second, and probably more important, is psychological skills to outmaneuver (or at least to match) the subject.

© Robert Ganz

Tips for kid-friendly photos:

• Stoop to your subject's eye level or lower. Shooting from below a child's eye level can create a compelling photograph.

• Be prepared, to shoot quickly and often.

• With young children, have an assistant to distract, entertain, or otherwise guide interactions and poses.

• Create an enjoyable, distracting activity to make the session fun.

• Shoot in two 2-minute spurts and then take a play break before starting again.

• When the going gets rough, end the session. Better to try again when your subject is in the mood.

Photographing Adults

You have two basic choices in photographing adults: the "official" portrait or the spontaneous grab shot, sometimes known as a candid. Which you choose depends on your own preferences and the situation you are in. It's pretty hard to do a portrait in the middle of a party. So that's a good time for a spontaneous grab shot.

The Formal Portrait

Creating a portrait requires a bit of time and some forethought. If you're experienced, schedule a minimum of 15 minutes; up to an hour if you're not experienced or if you want to do several poses.

Before you start the session, do the following:

- Determine the type of portrait and pose you want: head-and-shoulders, environmental, or candid.

- Arrange a suitable portrait setting—most important may be the available lighting; a chair near a large window without harsh sunlight works well.

- Discuss the look you or your subject desires ahead of time.

- Schedule enough time so you can proceed leisurely and prep the subject.

- If you have special make up, prop, or clothing requirements, go over them with your subject.

- Prepare ahead of time. Set up your equipment (reflector card, flash, tripod) before the subject arrives.

- During the session be confident and in charge. But be friendly and talkative to keep your subject relaxed and cooperative.

Be aware of the many small things that can ruin a portrait. Are the eyes closed or looking the wrong way? Stray locks—charming or distracting? A hand curled like a claw. A profile of a person with a big nose—does it add character or stress a flaw? Is the neck twisted causing tendons to rise like anchor rope? Sunlight hitting the tip of the nose? A pimple on the left cheek, while the right cheek is clear.

Seemingly a simple picture, a portrait consists of thousands of little details and a few big ones. Your job is to decide what is important and what isn't. The most obvious is pose and body position, especially head and hands. But as you arrange your sitter, make sure the big things work and that none of the little things become big things that can ruin a picture.

• Eye to Eye: Where should the subject look? A person looking directly at the camera can create a picture that immediately draws in the viewer.

At the same time, that direct eye contact can seem intense and excessively personal. For a more delicate portrait, direct the person to look down or off to the side.

• Use Props To Add Interest: An appropriate prop can add interest and tell a story. What sort of prop? A book, a soccer ball, a clarinet, a golf club. Be sure it doesn't interfere with the pose you are trying to achieve or become the center of attention.

Choose the Right Light

Professional photographers spend large sums of money on lighting equipment that makes their clients look great. Most of us have to rely on daylight. But the quality of daylight varies tremendously.

• Diffuse light—best all around: Diffuse light can come from an overcast sky or from a window not facing the sun. It is the best light because it flatters people. Its soft illumination smoothes the skin and eliminates squinting. Use it when you want to create a traditional portrait. You may want to have an assistant hold a poster-size white board a few feet from the subject's shadowed side and angle it to reflect light back onto the face for extra dimensionality.

• Add energy with backlighting: Backlighting occurs when the subject's back is to the sun. It creates an attractive glowing rim of light on the hair and shoulders. Since the sitter's face will be in the shade, you may want to brighten it with a touch of your camera's flash.

• Frontlighting for everyday pictures: Frontlighting is when the sun shines into the face of the subject. It typically causes squinting, but it evenly lights the face. To avoid the squint-eye look, try asking the person to close their eyes and then upon the count of three to open them wide. When you say three, press the shutter button, so you capture that split second of wide-open eyes before their reflexes cause them to squint against the bright sun.

• Toplighting—avoid at all costs: When the bright sun shines down from overhead, deep shadows often mar the face. The nose becomes a mountain, the eyes look like caves. It's an effect to be avoided. Use fill flash or a white poster board to add light that reduces those ugly shadows.

• Fill flash for outdoor portraits: Read your camera manual to learn how to use your camera's fill flash. Some cameras have one setting for fill flash. You simply activate it,

© Charlie Brethauer

and then the flash fires with reduced energy. It lightens facial shadows and adds a sparkle to the eye without blasting away all the shadows. If you're having trouble figuring it out, simply turn on the full flash, then stand two to three steps from the subject and adjust your zoom lens. If the results are too dark, move a step closer; too bright, take a step back.

Candids

Candid photographs are those you take when the person is engaged in an everyday activity and not expecting to be photographed. Done right, they are natural, relaxed and revealing because they show the real person.

Don't over-orchestrate this. Pick out the right situation and the right moment and consider how light, background, and other factors will affect the outcome. Again, the goal is a natural, seemingly spontaneous picture.

© Kevin Kopp

Use a White Card for Pleasing Flesh Tones

Critical to all people photography is creating pleasing flesh tones. In short, skin color needs to look natural and healthy. If it's just a tad blue or green, the picture may appear awful.

Here's where white balancing features in your software can help—if you set up the picture correctly. If your subject isn't wearing anything white, add a small (credit card size) white card or piece of paper in a corner of the picture that you can later crop out. Make sure it is lit the same as your subject's face.

When you open the picture in image-processing software, you can use the Highlight Eyedropper tool in Levels or Curves to click on the white card. This neutralizes the color balance and should give good skin tones.

Make a Silhouette

Silhouettes are fun and fairly easy to make. All you need is sunshine pouring through a window and a white curtain. Pull the curtain across the window. Seat your subject on a chair about two feet in front of the curtain. Set your camera's exposure compensation control to –1 and start taking pictures. You should end up with a black profile against a white background, which you can fine-tune by altering contrast and brightness in your image-processing program.

© Charlie Brethauer

Closing in on Close-Ups

Up close, the world is an amazing place and one we seldom see. Often we are so busy we miss the details all around us.

Digital cameras are exquisitely suited for close-up photography. Sharp digital pictures are created by lenses that focus close, an LCD that shows a true view of a subject up close, and (frequently) image stabilization technology. Because so many digital cameras use a fairly small sensor, the depth of field is greater than it is with a film camera. That means the picture is more likely to be sharp from front to back. Nonetheless, close-up photography offers many more challenges than everyday picture taking.

The Close-Up Mode

Many digital cameras require you to activate a Close-Up mode, typically a button or menu item represented by a flower. Once turned on, it allows you to focus the camera close to the subject. Some D-SLRs don't have a Close-Up mode, and simply require you to use a macro or close-up lens.

Hold It Steady

Image stabilization makes it easier to counteract blurred pictures caused by an unsteady hand. And the effects of that unsteady hand are magnified in close-ups. So try to use a shutter speed of 1/125 second or faster. Better yet, use a small tripod. Not only does it offset camera motion, it will put the camera in one spot, so you won't be able to move the camera closer or farther from the subject, which can throw it out of focus.

Use a Small f/stop to Increase Depth of Field

Depth of field (front-to-back image sharpness) is less of a problem with snapshot cameras—but it's still a problem. If you can select your camera's f/stop (aperture), set it to f/8, f/11, or f/16 to give the picture overall sharpness.

Know Your Camera's Close-Up Capability

How close can it focus? Does the close-focusing distance vary with different settings of the zoom lens (probably)? Does your camera have image stabilization? If so, use it to minimize picture blur that results from even slight camera movement.

Align Camera to Subject

You can maximize overall sharpness by aligning the camera lens so it parallels the position of the subject. Think of two people reaching out to shake hands. Before they clasp hands, they align their palms so they are parallel to each other. Similarly, align your camera lens to the subject and you'll increase overall picture sharpness.

Does Your LCD Articulate?

Do you have one of those fancy LCDs that twists and turns? It can make ground level close-up photography much easier. Instead of kneeling low and twisting your head to see the preview, you simply twist the LCD to face you.

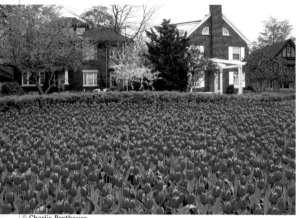

© Charlie Brethauer

Revealing the Beauty of Flowers

Flowers are as cheerful in photographs as they are in person. And having a big bouquet of them as a computer screensaver or framed print will brighten your life.

Topped off by a well-defined and prominent blossom, many flowers resemble the human form. Not surprisingly, they benefit from similar techniques used for photographing people, be it an individual or a group.

One major difference is that the smaller size of most flowers will likely require you to use the Close-Up mode. That means you should use the LCD (not an optical viewfinder) to accurately position the flower within the picture area.

© Kevin Kopp

Here are several tips for making a flower as attractive in a photograph as in a garden.

• Get Down to the Flower's Level: Kneeling to get an eye-level perspective draws viewers into the picture. If your camera has an articulating LCD, use it.

• Isolate the Flower: Most flowers look best when all attention is focused on them. That means there shouldn't be any obvious competing subjects behind them. You can achieve a simple background either by choosing a good angle or by placing a black poster board behind the flower. Move away distracting debris, push aside interfering leaves, and gently blend the blossom to a favorable position.

• Choose Attractive Lighting: Backlight works well with translucent flowers, overcast light for showing subtle hues and pastels, while bright front light flatters boldly colored flowers.

• Hold your position firmly, using a tripod if available: Close-ups readily show blur from a moving camera and from improper focus, common in close-ups if you shift the camera slightly after focusing.

© Charlie Brethauer

Creating Compelling Pictures

You found a subject to photograph. You're about to take its picture. But wait. Stop right there. Have you considered the options, the alternatives, the many creative choices that could rocket your picture to artistic stardom?

Read and experiment—the most creative technique of all is trial and error. Don't worry about the inevitable goofy picture. Simply delete and learn from it. Soon your gallery of artistic compositions will draw a crowd at your next party.

© Charlie Brethauer

Although camera design seems to guide you to place a subject in the center of a picture, don't! The center is dull, static, and lifeless. Start with the infamous rule of thirds. It suggests placing an imaginary tic-tac-toe grid over the picture area and placing the subject on any grid intersection.

But don't become a slave to a grid. Simply position the main subject in the picture area best suited for the scene it's in. Sometimes that may even mean placing it in the center.

Life Isn't Always Horizontal

Most cameras are designed to be held horizontally. Naturally, most of our pictures are horizontal. But quite a few scenes deserve vertical treatment. For instance, the Eiffel Tower and Statue of Liberty. Before you take a picture, decide whether it should be contained within a vertical or horizontal format. It's that simple. In doubt? Shoot it both ways.

© Charlie Brethauer

Exercise
Your Angle of View

Don't just stand there and take a picture. That's the lazy approach—artistically and athletically. How about moving partly behind your mother and having her look into the distance? Or turn that tulip into a towering skyscraper. How? Just put your camera on the ground and point it upwards at the tulip. Where you place the camera when taking a picture

is a critical decision in the appearance of the picture. Not every picture deserves an unusual angle, but don't take the angle of view for granted. It's a powerful creative tool.

© Charlie Brethauer

Show off the Subject

Your subject should be the center of attention. You can make it stand out with these techniques:

- Isolate it so there's no question it's the subject.
- Move in close so it fills the picture frame.
- Arrange the scene so secondary elements point towards it. Contrast it from the rest of the picture by using a plain background, throwing the background out of focus, or by making it much brighter or darker than other picture elements.

Guide the Eye

Hidden in the scene are both obvious and implied lines and shapes, such as winding roads, seawalls, a line of trees, and a triangle of cockeyed lichen-covered gravestones.

Choose a camera position and arrange the scene to use these elements to create a pleasing arrangement, connect separate areas, or direct the eye through the picture. Harmonize the elements so they work together for a more powerful picture.

Showcasing Scenery

Scenic pictures appeal to almost everyone. When you travel, you want to be sure you get pictures that capture the beauty and the drama of your destination. To make sure you capture all this scenic splendor, you should apply some proven photo techniques.

© Charlie Brethauer

Anchor the Scene

Some landscapes are so dramatic they can stand by themselves. But when depicted in a picture, most need a recognizable subject that draws in the eye and then frees it to explore the landscape. Try to include something—a barn, a lone tree, or a canoe—that sets the stage for the greater scene.

Find Dramatic Light

Dramatic lighting can transform an ordinary subject. You probably can't focus your vacation around your photography, but go for the exciting lighting that begins and ends each day. The beautiful colors of

© Charlie Brethauer

twilight and the raking golden sidelight of the sun near the horizon enhance almost any subject.

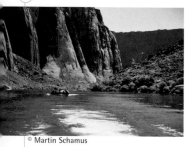

© Martin Schamus

Use Scale to Reveal Grandeur

Turn molehills into mountains and mountains into continents by including a smallish subject of known size in the picture to create scale. A distant horse in the valley, a chapel clinging to the side of a cliff, a fisherman dwarfed by a waterfall. By including a subject of known size you can make the scene seem immense.

High Horizon, Low Horizon

Most scenics include a prominent horizon. Where should you place it? Generally, don't place it in the middle because it tends to cut the picture in half, creating two weak pictures instead of a single strong one. Place it low, when the sky is interesting or you want to create a sense of freedom and expansiveness. Place it high to include an interesting foreground or emphasize distance.

© Thom Gaines

Expand the Scene

With a wide-angle lens and a subject in the foreground (5 to 20 feet away), you can stretch the apparent distance of a scene and make it seem much more three-dimensional. To make the entire scene

sharp from foreground to background, use a small aperture (f/8, f/11, or f/16) and focus about 8 feet away. Try to find a somewhat interesting foreground subject: an unusual rock or log, your dog, or a bicycle.

Create a Multi-Shot Panorama

Have you ever been stymied by a vista wider than the widest view of your camera? Create a multi-shot panorama. You may not have done it yet, but it's easy. Keeping the horizon aligned from shot to shot and shooting from left to right, you simply swivel the camera so the next frame includes about 10% of the right side of the previous frame. Take three or four shots and later join them, using built-in camera or image-processing software. Using a tripod makes it easier to align the horizon.

Tapping the Potential for Travel

You booked your trip nearly a year ago, dreaming about the vacation that awaited you: glimmering beaches, snorkeling in aquamarine waters, and delicious seafood placed before you as the sun melts into the horizon.

And now you're on your way. If your planning included just a few minutes of photo preparation, you'll return from your trip with pictures that'll let you daydream the rest of your life. Or hang as masterpieces on your walls.

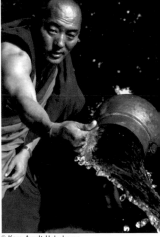
© Kara Arndt Helmkamp

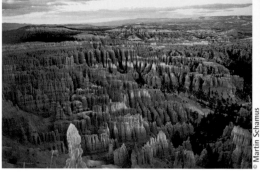

© Martin Schamus

Planning

The main goal is to keep you shooting during your travels—
whether they last a day, a week, or a month. The first step
in doing that is to take a couple of pictures a few days
before you leave to make sure your camera works.

The next goal is to make sure you're equipped to handle
the situations you expect—and don't expect. Before you
leave clean your gear and charge your batteries. Organize
your gear in a camera bag and keep it looped over your
neck at all times. And don't worry about airport x-rays;
they won't hurt your digital gear or images. If you're carry-
ing some film, try to get it hand checked, especially ISO 400
or higher film.

Here's what to take to get great pictures of your travels.

Freshly charged batteries
Extra batteries
Battery charger
Extra memory cards (enough for minimum of 200 pictures)
Safe storage of filled memory cards
Polarizing filter
Small tripod
Cleaning kit
A backup pocket camera
Knowledge of emergency destination photo resources
(retail stores, internet cafes for downloading)

• Research places to photograph: Before you leave, do enough research to assure yourself you'll get the pictures you want. That might be a little or a lot depending on your commitment and desires. And it probably helps to find actual photos of the places you want to visit, preferably during the time of year you're going. If you're very organized, develop a photo itinerary and plan of attack for each site you plan to visit.

Local People

Capturing native dress, manners, behaviors, hairstyles, occupations, and personal interactions adds color and insight to your travel pictures. Many local people enjoy being photographed. Some hate it. Some charge money for it.

© Charlie Brethauer

Some of the best places to find the action are the outdoor markets and cafes, where neighbors gather in lively interchanges or nod off after a full meal. Whenever photographing people during your travels, be discrete, but not sneaky. Work from a distance with a telephoto lens. When in close, smile and ask if you can take a picture. A small purchase often obtains you that privilege. Above all, be polite and recognize that not all cultures welcome the intrusion of a camera.

Note: Make sure to ask first before photographing military or government personnel. It is not always welcome in this era of high security consciousness.

Pictures from Planes and Trains

Some of the most spectacular vistas occur when you're on a plane or train. You can get good pictures if you overcome some challenges. The first and most difficult may be the window you're looking through.

Clean off the inside with a tissue and then place the camera lens against the cleanest area of the window. If the window vibration is strong, hold the camera lens just off the window's surface. If reflections appear, cup your hand around the lens to block them.

Use a high shutter speed. With trains, use a slight telephoto setting and frame the scene to exclude areas within one hundred feet of the train. If you include trees, fields, or other objects near the train, they will zip by so fast that they will almost certainly be blurred in the picture (sometimes that creates an interesting effect).

Interiors

Whether it's the amazing arches of Notre Dame or the exquisite woodwork in Williamsburg, you'll encounter museums, cathedrals, historical houses, and other famous buildings with unique interiors.

First check to see if you are allowed to photograph inside your location. Most but not all places allow photography. Many prevent use of a tripod or flash. And for those that permit flash, remember a built-in flash will illuminate objects only within ten to fifteen feet.

© Thom Ga

• Capture some details: Sure you want to show everybody the grandeur of the ballroom, but significant details often best tell the story of

opulence and amazing architecture. Move in close for the details of the carved mantle, the fluted column, gargoyles glowering from carved stone.

• Use a higher ISO: In dim interiors, use a higher ISO setting, such as 400 (because of digital noise, ISO 200 is a better choice for most snapshot cameras). But most importantly, use a steady camera technique. If your camera has image stabilization, turn it on. If not, hold the camera against a column, doorway, or atop a chair and slowly press the shutter. You may get good results down to 1/8 of a second using these techniques.

• Match the white balance setting to the lighting type: If the interior is lit by tungsten or fluorescent light, set your camera's white balance to correspond to the type of light. When in doubt, use the automatic white balance setting.

• Underexpose stained glass and candles: If you're including a stained glass window or other illumination as part of an overall picture, it will probably be overexposed. To hold detail in stained glass windows and candles, try underexposing 1/2 stop. Check your camera's built-in histogram to make sure the bright areas of the scene are inside the far right side of the histogram.

© Charlie Brethauer

Tell a Story

Stories have a beginning, middle, and an end. They have variety and pace. And usually a plot. You may tell a short story that covers one part of your trip or a complete story with several chapters. Include signs to orient viewers.

Take a sequence to reveal an event (outside of the café, family seated at the table, main course, dessert, siesta). Add in shots of your transportation mode and accommodations for segues. Mix close shots with far, daytime with night, meals with scenics. With enough pictures on hand, you can easily build a story.

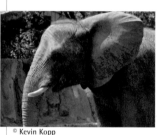
© Kevin Kopp

Go Wild at the Zoo

At the newer zoo parks, you can get some amazing naturalistic pictures of animals seemingly in their environments. And if you stay until near closing time, you might even get pictures of them silhouetted against the setting sun—shades of the Serengeti.

But in reality, zoos are unnatural environments that allow you to get near exotic animals. Yet you'll find a few common obstacles—some imposed by the zoos, others by the animals—that you'll need to overcome. These include visual barriers, hiding animals, and animals at great distances. Review zoo literature and signs to learn when animals will be active or fed. With a little patience and a few tricks you can create eye-catching pictures of some of the most amazing animals on earth. One note: do nothing to risk your safety or that of the animals.

Obscuring Obstacles

Chain link fences and dirty Plexiglas windows often protect you and the animals from each other. At the same time they obscure your camera's view. Find or clean a spot on the window and gently press your camera lens against it. With your camera almost touching the fence, try to center your lens between the wire links. And then for both fence and window, use a large aperture (such as f/2.8 or f/3.5) and a telephoto setting to throw them out of focus. Sometimes you can use a fence or other obstruction as a visual element in the picture.

Bring on the Food

Where can you find the family dog at dinnertime? Just as you know your pet's behavior, professional wildlife photographers know the behavior of their quarry. You should, too. Like people and pets, zoo animals look forward to food and know when and where it arrives. Find out the feeding times of your favorite animals. Get there a few minutes early and pick out a good photo spot. For animals you're allowed to feed, buy some official food and use it to draw the animals to a good photo location.

Good Telephoto Practices

When you use your telephoto setting, use sharp picture techniques to minimize picture blur from camera movement. These include using the image stabilization if available. Setting a fast shutter speed, such as 1/500 or 1/1000-second, steadying the camera on a wall or bench.

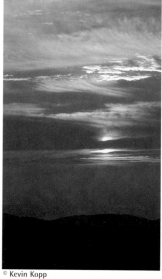
© Kevin Kopp

Sizzle Your Sunsets and Sunrises

Whether that great ball of fire is slipping below or rising above the horizon, it can create a glorious scene. Sometimes it can put on a shining solo performance. More often it needs a supporting cast. But most of all it requires a little patience. And it needs you to get there on time and stay until the end. Sunrise skies typically ignite 15 to 30 minutes before the sun breaks the horizon. Sunset skies often reverse the trend, exploding with color just before the sun reaches the horizon. Remember to avoid eye damage by not staring at the sun and by using the LCD to compose the picture instead of the optical viewfinder.

Telephotos Make It Big

That setting sun may seem enormous. It isn't. If you use a wide-angle lens, the sun will appear as a small dot. To keep it big looking in your picture, set your lens to a telephoto setting of 100 to 300mm. Again, don't stare at the sun through your camera's optical viewfinder. Instead, use your LCD if available to compose the picture.

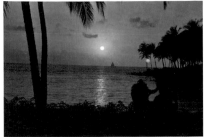
© Martin Schamus

Enliven with a Silhouette

The monochrome orange of a sunset can seem a bit boring.
You need black to enliven it. Add a tree, a lighthouse, a
barn, a person, or other subject that creates a strong
appealing silhouette to embolden your picture.

Look the Other Way

Like a hypnotist swaying a watch in front of your eyes,
sunsets can be mesmerizing. Periodically break that spell
by looking behind you to see what the sun is illuminating.
Painted with orange lighting, and casting long soft shad-
ows, many subjects create haunting scenes with these the-
atrical colors.

Water Reflections

From kaleidoscope to an
enormous mirror to a thou-
sand prisms, the effects of
interactions between water
and light, especially orange
light, are breathtaking. Use
a telephoto setting to cap-
ture the orange sparkles of a
wave breaking over a rock or

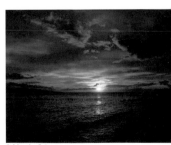
© Martin Schamus

the pattern of ripples in the wake of a passing boat.

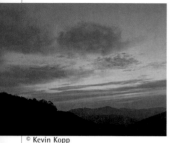
© Kevin Kopp

Wait for the "Beforeglow" and Afterglow

When the sun is below the horizon, a whole new world of color spreads across the sky. Some you can't even see, but your camera can. That's because when the sky is dim you need a longer exposure (and a tripod) that captures colors unseen by your instant-seeing eyes. Variable violets, subtle salmons, pretty peaches, retiring roses: a whole new palette peeks out when the horizon hides the sun's brilliance.

Bracket Your Exposures

For a starting exposure, point the camera at the bright sky near the sun but excluding it. Set that exposure. Normally it will give you good results. But also, using the exposure compensation control, take additional pictures at +1 and −1 exposure settings.

Exercise Your Sports Shots

She pivots and shoots. The goalie dives with outstretched arms. Your five-year-old ducks and scrambles between his father's legs. Split-second reactions and anticipation may be more important for the photographer than the athlete. Whether backyard or organized, the athlete is always a step ahead of the photographer.

That's why the photographer has to be ready. When the action is fast and furious, perhaps the most important tech-nique is the simplest: Take lots of pictures. The following techniques will also help to increase the yield of your sports or action photos.

Position Yourself

Find the spot that gets you closest to the best action (near the goalie, the basket, etc.) without interfering with the game or endangering yourself.

Try a Low Viewpoint

Low angles make the players seem strong and powerful. They will seem to loom over you. From a low angle even the tykes seem towering. Choose a dynamic angle; shooting three quarters head on captures expressions while imparting movement.

Prefocus and Anticipate

Prefocusing shortens the camera reaction time so you're more likely to catch split second opportunities. Prefocus on the anticipated spot of action by partially depressing and holding the shutter button. Fully depress the shutter button to take the picture.

Snap Just Before the Climactic Moment

Both you and your camera take a split second to react. If you wait until you see the climactic moment, you've missed it. Take the picture just as it is about to occur.

Use Action Functions

To get an action-stopping shutter speed, set the camera to one of the Shutter Priority or Action mode. Read the manual to see how these functions work with your camera and what other action functions your camera offers. If possible, set the camera to continuous servo focusing so it rapidly adjusts focus on moving subjects.

Pan the Camera to Convey Motion

When the action is a blur, that's a good time to try the "blur" technique of panning. Set the camera to a slower shutter speed such as 1/30 second. Track the subject in the camera. Moving the camera smoothly, press the shutter button. The result is a picture with a fairly sharp sub-

© Charlie Brethauer

ject and a blurred background. The slower the shutter speed, the greater the blur.

Use higher shutter speeds, such as 1/125 second for race-cars and galloping horses. Medium shutter speeds, 1/30 or 1/60 second, for runners and bicyclists, and slower shutter speeds, 1/15 second, for joggers. And experiment with shutter speeds, as results are somewhat unpredictable.

Freeze Fast Subjects

High-speed subjects zoom by you almost before you can press the shutter button. Freezing them so they're sharp in a picture requires a fast shutter speed. Maybe the fastest on your camera. In bright sunlight and lightly overcast days, use a shutter speed of 1/2000 second or faster. It will stop the action dead and counteract any camera motion blur when you use a long telephoto lens. The result will be super sharp pictures.

Creating Family Event Pictures

Here comes the bride... Happy birthday to you... Big events and cameras go hand in hand. A big event is like a play. It comes with a clear cast of characters and a specific sequence of acts that usually follows a predictable plot with a traditional script.

The lead characters deserve your attention, but the secondary players often steal the scene. Most important for you is to catch the climactic moments—the blowing out of candles, the I do's and congratulations.

The more significant the event, the more you should be prepared— especially if you are the primary photographer and especially if you are taking pictures away from home. That means freshly charged batteries (with spares), a spacious memory card (with spares), and a plan in your head of what pictures to take.

Stay Within Flash Range

Photographing an indoor event? Then you'll be using the flash. Look out for the number one flash problem: photographing subjects too far away. That built-in flash is relatively weak. Keep subjects within 10 feet (3 large strides from the camera) so they appear bright in the picture. Beyond 10 feet, they may appear too dark.

Here's another tip: When taking lots of flash pictures, try to wait a few extra seconds after the green ready light glows, so you know it will be fully charged.

Photographing a group with flash? Keep the group compact and arranged horizontally with no more than two rows. With groups arranged in rows of three or more, those in the back are usually too dark and those in the front too bright.

Try a Few Without Flash

Are you a risk taker? Maybe you shouldn't be if you're the primary photographer. But if you are photographing lit candles on a cake, know that the flash overwhelms them. Try taking a few pictures with the flash off to capture the glow of those candles.

Portray the Emotions

Tears, giggles, and big hugs abound at family events. Walk in or zoom in close to fill the picture area with expressive faces. Expressive faces are fleeting, so work fast and take lots of pictures.

Catch Key Participants

Don't forget the leads in this play. Follow them about and reveal their activities during the entire event. And arrange all the key participants into a group picture. Later you can build a story or chronological album of the event.

© Charlie Brethauer

Show Significant Details

Details are important. The roses on the cake, the place settings, even the party favors. Details are the spice of your picture taking. You need a dash of them to add variety and taste to any story or album.

Hand Out Party Favor Pictures

Don't let guests go home without a souvenir picture. When the festivities begin winding down, hand your camera to your backup photographer and start making prints to hand out as party favors. Keep them small (perhaps 4 x 6 inches-10.1 x 15.25cm) so you can make a lot fast.

If you can, set up a printer in the party area. Soon people will gather round and ask for prints to take home.

Index